# Leisure Arts 32

## Painting
# Still Life in Watercolour

### Benjamin Perkins

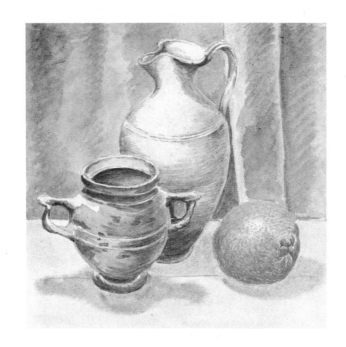

SEARCH PRESS

# Introduction

Still-life painting can require as great skill, and demonstrate as much subtlety and sophistication of technique, as any form of painting. But it can also be reduced to forms so simple as to be almost abstract. The simplest paintings are often the most eloquent: witness the work of artists such as Cezanne and Van Gogh.

This is one reason why still life is a good starting point for the would-be watercolourist. Another is that it allows more time for consideration and experiment. Once you have chosen and arranged your subject matter in the studio, it will stay there as long as you wish. It is captive to your fancy – you can study it from different angles, sketch it, paint it, alter it and paint it all over again if you want to. It will not become restive, or dull, like the sitter for a portrait and, so long as you work in a north light, it will not be subject to the constant fluctuations in light intensity which so often bedevil the landscape painter.

Still-life painting will also give you infinite opportunities of experimenting with your palette, using both pure colours and mixtures, and of dealing with problems such as reflected light, deep shadow and the simulation of various textures, all of which will stand you in good stead, whatever type of painting you may undertake in the future.

In the demonstrations in this book, I have outlined my own techniques, and have indicated the brush sizes and pigments that I prefer. Good quality brushes, preferably sable, are important, and I would suggest a rough, or not, paper, rather than hot-pressed, for any but the most detailed and miniaturized still-life pictures. But I would stress that these are personal preferences, founded upon my own style of painting, and I would urge anyone who feels happier with a freer style to use, perhaps, larger brushes and more liberal applications of water, with a bolder use of colour and more flowing lines, to cast aside constraint and do whatever comes naturally.

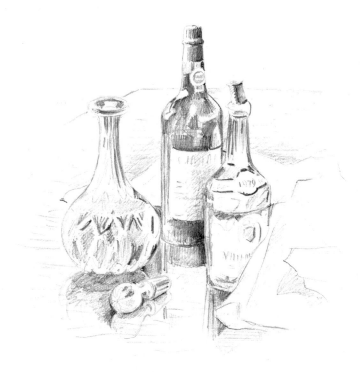

*Preliminary pencil sketch for the 'Bottles and decanter' demonstration on pages 9–11.*

# Preliminary sketch

Before I start any still life, having decided on the elements of which it is to be composed, and having moved them around until I am reasonably satisfied with the way they are set out, I always make at least one, often several, quick pencil sketches. These give me a better idea of how the final picture is going to look than I can get from just surveying the objects in the context of the studio at large.

# Jug, pot and orange: demonstration (pages 4–5)

Original size: 252mm × 252mm (10in. × 10in.)
Paper: Fabriano Not 140lb/300gsm
Brushes: Sable no.4

I am starting with a very simple composition, in which none of the objects has a glazed or highly reflective surface, the problems of which I will describe in later demonstrations. Here I am using two pottery vessels and one orange, which stand on a plain wooden table with a dark curtain as background.

## Stage 1 (page 4)
After arranging the group, I draw it in outline, using an H pencil. Next I wet the background area and then apply a very dilute wash of sap green mixed with raw umber. When this is dry, I add the foreground wash of light red and raw sienna and, while this is still wet, I drop in a little of a darker shade to indicate the pattern of shadows cast by the objects. The fuzzy edges of these shadows, painted wet into wet, will prove effective when I reach the finishing stages of the painting.

## Stage 2
Similar washes – though in this case put on direct without my first wetting the paper – are next applied to the objects themselves. In each case I use the palest colour present. Thus, in the case of the orange, the wash is of dilute cadmium yellow – when the picture is complete, this will only show through where the light is concentrated on the upper part of the fruit.

While the paint is still wet on the jug, a little chrome orange is added on its side, where the orange is reflected. It is well to note that a brightly lit object will reflect light even on to a very matt surface such as this.

## Stage 3
In this stage I complete the painting of the two pots, build up the shadowed areas and take careful note where the darkest tones are to be found and which areas are light enough for the primary wash to be left intact. Always be bold with colours – shadows, for example, are not just dull grey – particularly in the final stages use your brushstrokes in such a way as to convey an idea of the texture of the surface to be painted. The orange I leave at an intermediate stage using chrome orange and a little cadmium yellow – dilute at the top, more concentrated on its shadowed side.

## Stage 4
Having first completed the orange, by adding burnt sienna to the chrome orange in the shadowed area and using very small brushstrokes to suggest its wrinkled surface, I now start to paint the background curtain, blocking in the main areas of light and shadow which indicate its folds.

## Stage 5 – the finished painting (page 5)
The curtains I finish off by grading the dark tones into the lights and using short brushstrokes, towards the end of the process, in order to simulate the texture of the faded velvet. Finally I use a second wash to achieve the desired hue for the surface of the table. All that then remains is to indicate the graining of the wood and to intensify the cast shadows which, it will be noted, are darkest immediately beneath the object which casts them.

3

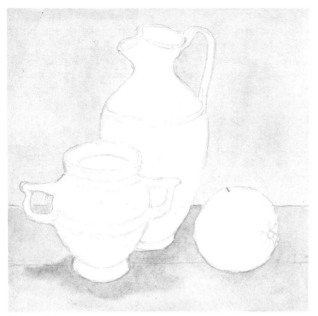

*Stage 1*

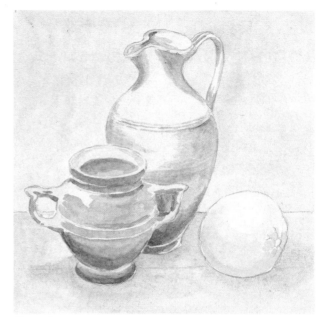

*Stage 2*

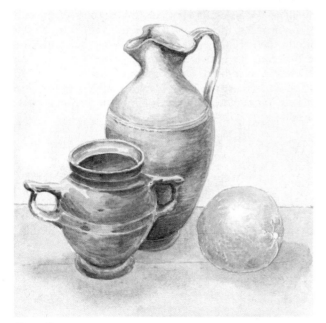

*Stage 3*

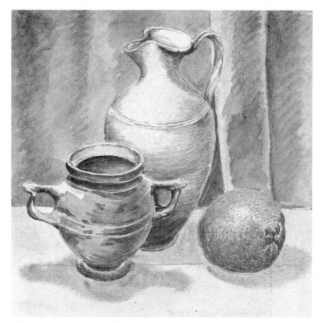

*Stage 4*

4

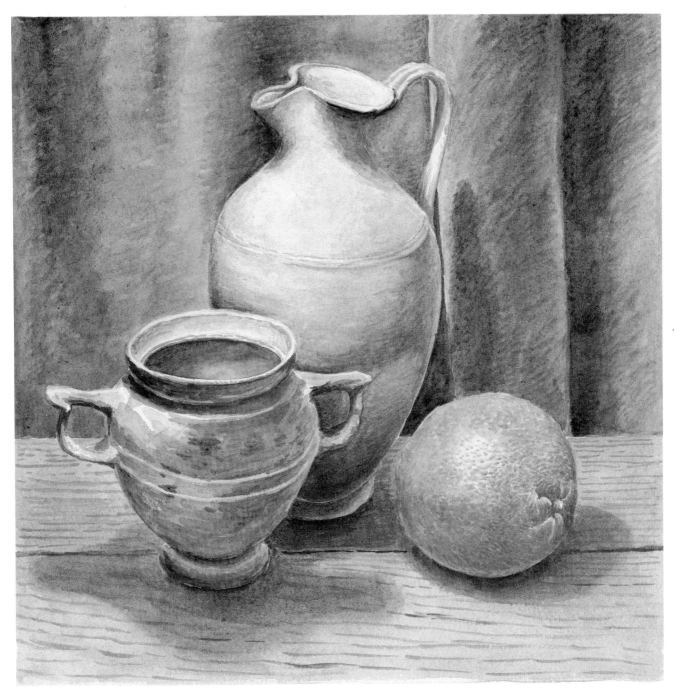

*Stage 5 – the finished painting*

# Composition and tone

Composition consists in organising the elements in a picture to create a harmonious whole. If you visit a picture gallery and look at the work of great artists, you will see that, although they come from different countries and periods of history, and work in a variety of styles and media, all their pictures display this quality of harmony, even though it may, in some cases, be arrived at by very advanced and subtle means.

Tone is essentially the use of colour or shading to provide light and dark areas in a picture, and since the contrast between darks and lights can be very great, their distribution becomes an integral part of composing a picture.

On these pages are some examples, which use three simple elements; two clay pots and an orange:

1. An object placed in the dead centre of a picture is unlikely to appear interesting, since dividing the space into uniform areas robs it of any element of contrast. The same is true of a group of objects placed in a symmetrical and equidistant pattern.

2. Here I move the jug a little to the left and forwards and place an orange beside it by way of counterbalance. I also alter the direction of the light so that the tonal values become less evenly distributed.

3. The introduction of a second, and smaller, pot helps to make a more interesting and satisfying group. At the same time I move the orange a little further to the right, so that there is a gap between it and the larger pot.

4. By providing a background and adding the cast shadows, the whole group becomes more substantial and dynamic. The lighting is from above, so I used a dark curtain behind the lit upper parts of three objects, while the white foreground contrasts with their shadowed bases.

5. Angled surfaces in the background can add to the interest of the composition.

6. Still-life objects may be viewed from a variety of different angles. Always experiment until you find the one that pleases you best. Here I take a more overhead view. Note also how the cast shadows in the foreground and the dark shadows on the objects themselves help to enliven the composition.

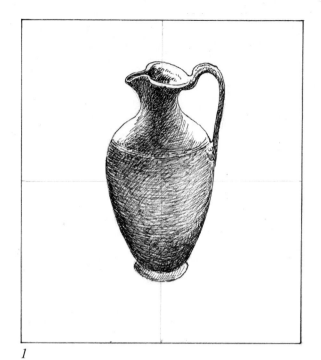

1

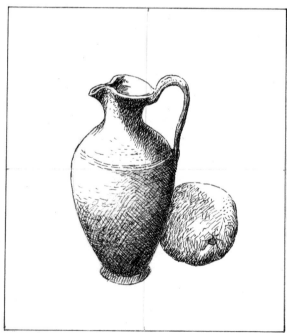

2

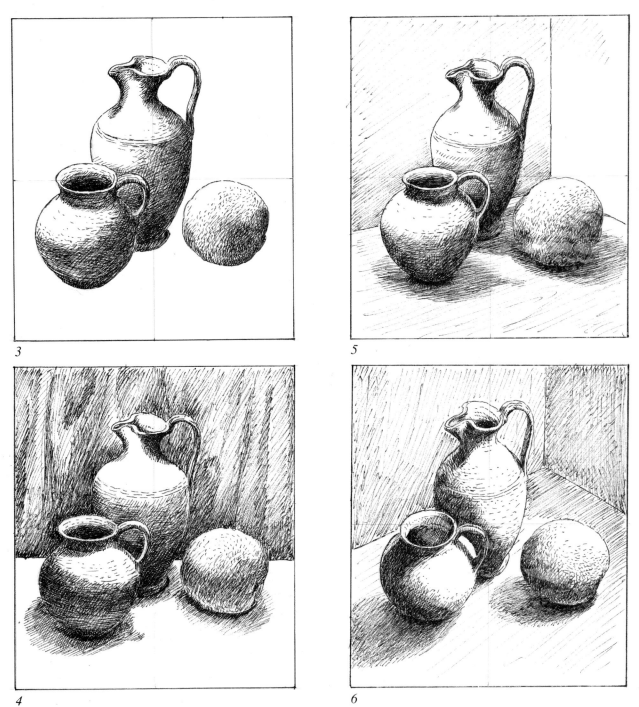

3

5

4

6

7

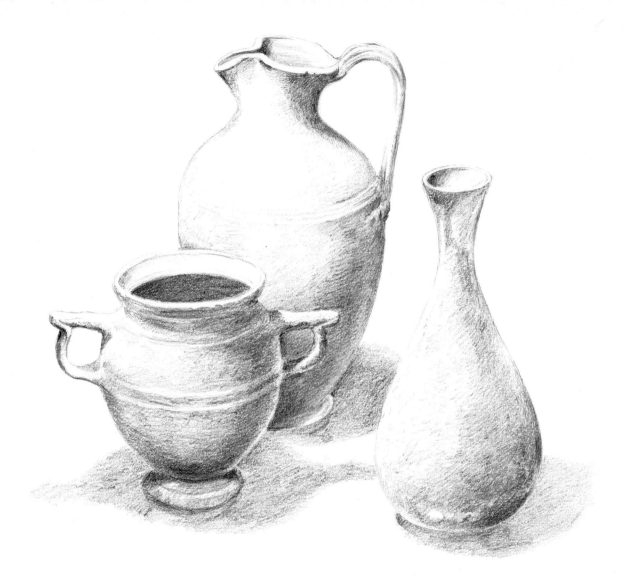

# Tonal sketch

Before embarking on a watercolour still life, it is useful
to draw a group of simple objects such as this, in pencil.
Being a much easier medium to control you can take
your time over it and study in detail the way the tonal
values are distributed, something that you will have less
time for when working in watercolour. You may be
surprised at what you discover. What appear to be very
dark edges on the shadowed sides of objects may seem
relatively pale when contrasted with deeper shadows
beyond, and you will find that, besides the principal
light source, there are also reflected lights to be taken
into account.

# Bottles and decanter: demonstration (pages 10–11)

Original size: 292mm × 200mm (10in. × 7⅞in.)
Paper: Fabriano Not 140lb/300gsm
Brushes: Sable no. 4

This demonstration (see page 2 for the preliminary sketch) is an exercise in painting highly reflective surfaces, of which there are five in the picture: the decanter, its stopper, the two bottles and the polished table. The white napkin is included both to soften the lines of the composition and because I want a background against which the very delicate colours in the green bottle show to best advantage. I use a no. 4 sable brush throughout, using the flat of the brush for the broad washes and the point for the details.

I have chosen to demonstrate a detail – the decanter – rather than the whole picture, because in the space available I can show the method more clearly in this way. The principle is the same for all such reflecting surfaces.

## Stage 1 (page 10)
It is important to know just how the cut glass pattern is arranged, even though its details may be lost in the later stages of the painting. This is a function of this initial drawing, for I am well aware that any inaccuracy at this stage may result in the final effect being distorted and out of perspective.

## Stage 2
The light source is from a window on the left which can be seen reflected on each of the objects in the finished picture. At this stage I identify the areas which are to be left white and put in touches of bluish grey and violet, some of which are in fact reflections of the sky. I also add a wash of chrome orange and cadmium yellow to represent the wine in the decanter. Since parts of this wash will remain visible when the painting is complete, the pigments should be as pure and brilliant as possible.

## Stage 3
I now begin to build up the darker tones created by the curved and faceted surface of the decanter. Besides the wine within it, these blobs and flakes of colour are influenced both by objects visible through the glass and by reflections on its surface.

## Stage 4
My object is to achieve an effect of brilliance and sparkle, by contrasting lights and darks and by using rich colours. Some mixing of pigments is no doubt going to be necessary, but I try to avoid too much mixing because that may result in a 'muddy' effect. The colours I use for the darker tones include, first, chrome orange and vermilion, then burnt sienna, crimson lake and French ultramarine.

## Stage 5 – the finished painting (page 11)
The two bottles have smooth, unfaceted surfaces, but my method of portraying them remains the same. I work from light to dark and ensure strong contrasts to give the impression of a high gloss.

The polished surface of the table poses a slightly different problem, because it is necessary to indicate not only the reflections of the objects standing on the table, which have a mainly vertical thrust, but also the shadows cast by those objects and the more or less horizontal graining of the wood. The way I deal with this is first of all to paint a light wash over the table surface incorporating the main areas of reflected light such as the streak of green below the smaller bottle, and then to build up the darks, working fast and using a rather dry brush, with the brush strokes following the lines of the wood's grain. Lastly I put in the very dark shadows that are cast by the objects.

*Stage 1*

*Stage 2*

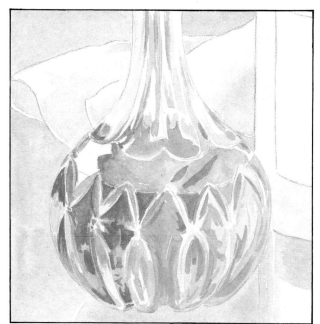

*Stage 3*

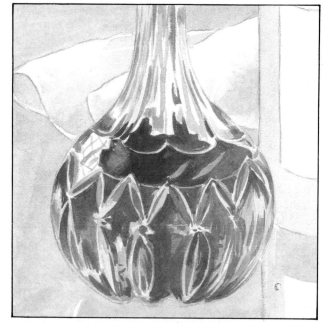

*Stage 4*

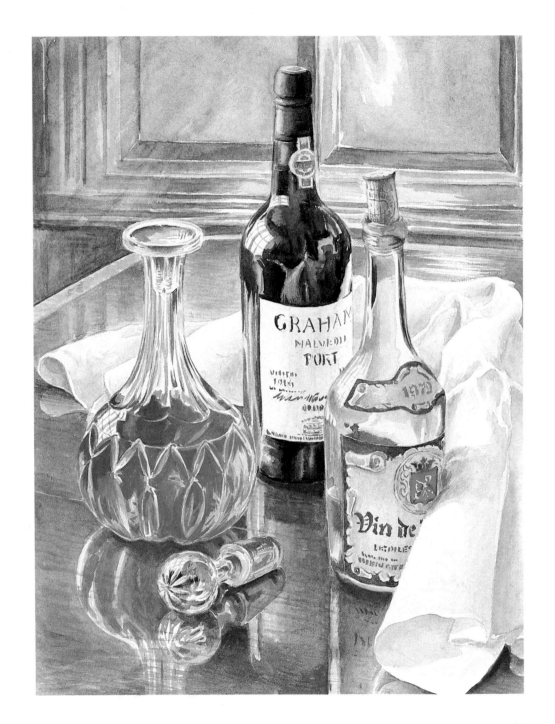

*Stage 5 –*
*the finished painting*

*A sketch in sepia paint of a pile of books seen in direct sunlight – see opposite page and the demonstration.*

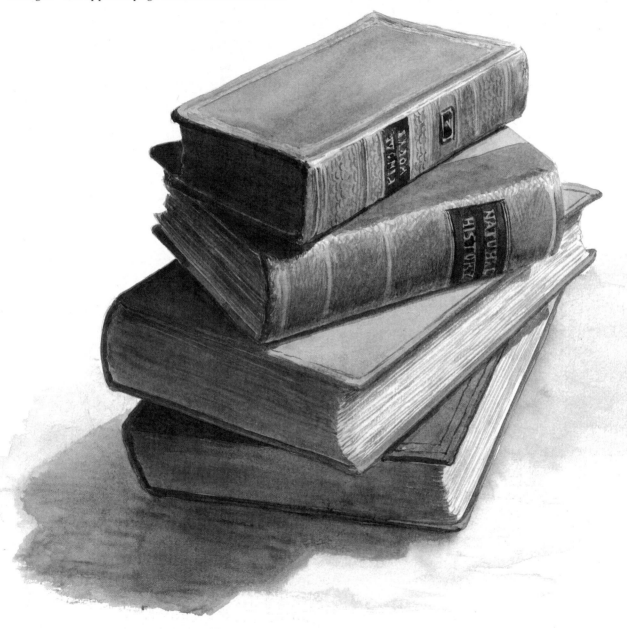

# Books on a desk: demonstration

Original size: 202mm × 230mm (8in. × 9in.)
Paper: Fabriano Not 140lb/300gsm
Brush: Sable no. 4

Books are pleasant objects; they can also be colourful and their bindings provide a variety of textures. In the context of still-life painting, a pile of books such as this is a good test of one's skills in accurate perspective drawing.

Here, the scene is a well-lit room, with a diffused light from a north-facing window. If the books were standing in direct sunlight, such as you might get through a south-facing window, the shadows would tend to be harder and darker. In order to illustrate this, I have made a sketch of a similar pile of books, in direct sunlight, using only sepia paint in order to accentuate the contrasting tonal values (see opposite).

## Stage 1 (page 14)

The drawing stage needs to be carried out with care, if I am to get the perspective correct from the start. The lines of the desk, window-sill and window frame form a kind of grid, being all at right angles to one another; but the books, laid at random angles, provide more of a challenge. If I do not get the perspective right at this stage, I will not have a chance to correct it once I start painting.

## Stage 2

I begin the painting with a light wash on all the broad surfaces – desk, curtain and window.

## Stage 3

Next I lay down the primary washes on the books and on the jar. Small areas of these pale colours will remain as highlights when the painting is complete.

## Stage 4

This demonstration shows the piecemeal way in which I build up the colours and tones, since I also add, as I go along, some details which I did not feel it necessary to include in the original drawing. While one area of the painting is still wet, I move to another, and so on. Brush strokes of varying thickness are used to indicate, for instance, the leaves of the books and graining on the leather binding. At this stage, too, I sketch in the design on the jar.

## Stage 5 – the finished painting (page 15)

I complete the painting of the books, and of the jar and its contents before putting the second, and final, wash on the desk top and finishing off the background. Last of all I add the shadows in the foreground.

If I compare the finished books with the earlier stages, I hope I have shown how quite simple variations in the way the paint is applied, and in the intensity of the highlights, can convey an impression of the texture of the surface one is painting. It ought to be possible to recognise, for instance, that the top two books are leather-bound, that the red book has a matt cloth binding, and the bottom book a glazed binding.

*Stage 1*

*Stage 2*

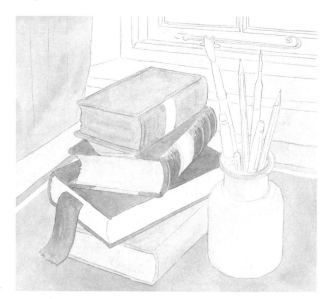

*Stage 3*

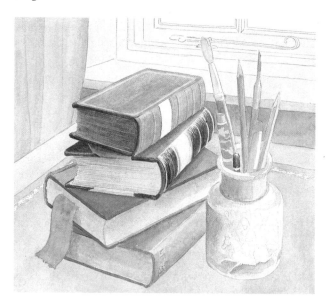

*Stage 4*

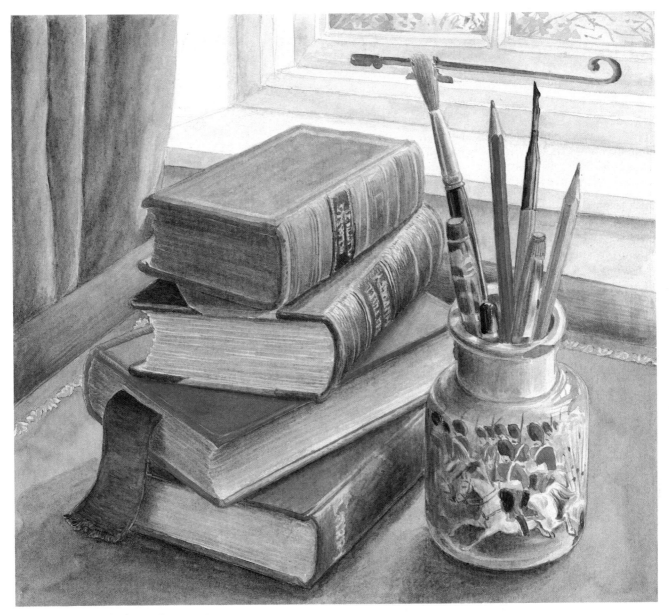

*Stage 5 – the finished painting*

15

# Roses in a blue and white vase

Cut flowers are enjoyable to paint, and during the summer months one generally has a wealth of different kinds from which to choose. I was lucky to find these for they were gathered from the garden in January.

Rose petals are very delicate organisms and require correspondingly delicate treatment in the painting of them. In particular, it is important to avoid giving them hard outlines and to let the brush strokes follow the natural creases and veining. Look carefully at the shadows on white flowers: they are never just a dull grey! It often helps with white or pale-coloured flowers to arrange them so that they appear against a background of dark leaves. This makes them stand out and intensifies their whiteness.

To paint the blue and white vase, I first paint in the shadowed area and then apply the blue decoration overall.

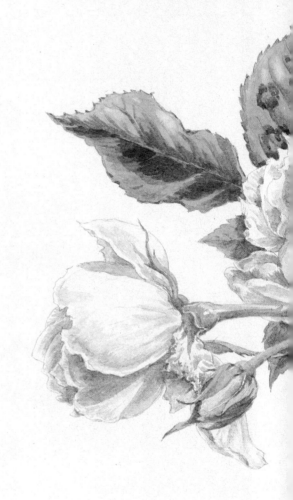

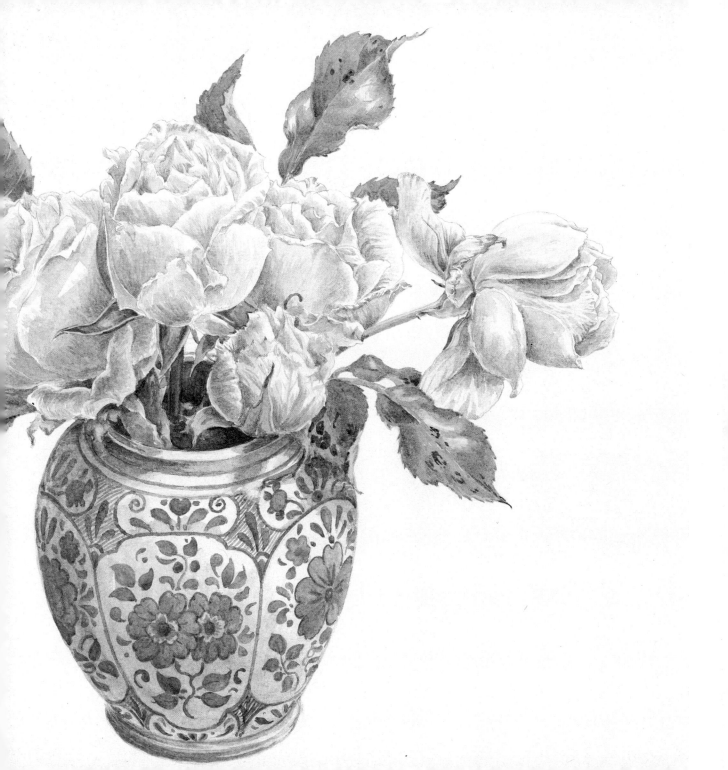

# The palette

Beginners are often advised to use a very restricted palette, consisting of, perhaps, only six or eight colours. However, I, personally, see no objection to adding to that, as time goes on, and experimenting with as many colours as you wish. Some you will find you hardly ever use, either because they duplicate others,

or because they can be satisfactorily mixed, and these can be rejected; but my paintboxes include some 40 colours, every one of which I find useful on occasion.

To give an example, the basic reds used in the demonstration painting which follows – the apple, the mango and the red plum – are cadmium red (mixed with chrome orange), scarlet lake and carmine respectively. In each case the use of these colours results in tints more accurate than I could achieve by mixing from a limited palette.

# Fruits: demonstration
(pages 20–1)

Original size: 292mm × 292mm (11½in. × 11½in.)
Paper: Fabriano Not 140lb/300gsm
Brushes: Sable nos. 4, 7

In this demonstration the stippling technique used to build up the shadows on the pimply-skinned ugli and lemon, has already been demonstrated in the case of the orange on pages 4–5 while the melon, the apple and the plums are painted with a technique that I have already demonstrated – building up the colours and tones with successive glazes, each applied after the last one has dried. With the lychees, also, the flakes of dark colour, which indicate their prickly surface, were applied after the primary wash was dry. I have therefore, to demonstrate the stages of the painting, concentrated on the mango because here, on account of its mottled and multi-coloured surface, I was forced to use a different technique, painting successive glazes wet into wet and only painting on to a dry surface at the very end. It was the most interesting of all the fruits to paint.

## Stage 1 (page 20)
The basic colours of the mango are yellow and red, so, having wetted the whole surface of the fruit, I start by blocking in the main areas of these two colours, using cadmium yellow and scarlet lake and letting the two colours merge where they meet. Note that, right from the start, I leave an unpainted area where the highlight is to be.

## Stage 2
Working quickly, before the paint of the primary washes dries, I begin to build up the colours using more intense hues and adding the patch of green in the lower part of the fruit.

## Stage 3
Still working wet into wet, I continue the process, using more concentrated paint and incorporating other colours such as violet, crimson, raw umber and yellow ochre where necessary. The mottled areas are created by dropping blobs of paint on to the paper with the point of the brush, first the yellow, then the scarlet, and letting them merge at the edges. If this is done with the paper too wet they will merge entirely and become orange, so timing is important.

## Stage 4
The process is continued in much the same way until I am satisfied that all the tones and hues are just right. If some of the blobs of paint, representing the mottled surface of the fruit, have been put on too dry, they can be softened and made to merge by rubbing over them gently with a slightly wet brush. This must be done with great caution, however, for too much water or too much pressure will result in lifting paint off the paper rather than in just spreading it; the hard-edged smear which you are then left with can ruin the painting, as it is virtually impossible to get rid of it, except by over-painting with a darker colour.

## Stage 5 – the finished painting (page 21)
To finish off the mango I have only to add the vari-coloured spots and speckles, some of which are applied wet into wet and others after the paint is dry.

For the group as a whole the final stage of the painting consists in deepening and adjusting the shadows on the fruits and the shadows cast by them on to the table. I remember in particular to take careful note of the light reflected from one fruit on to another. The apple, for instance, glows yellow where it reflects light from the lemon, and the ugli casts an orange light on to the melon.

*Stage 1*

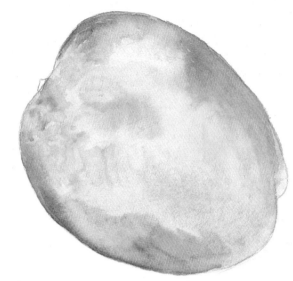

*Stage 2*

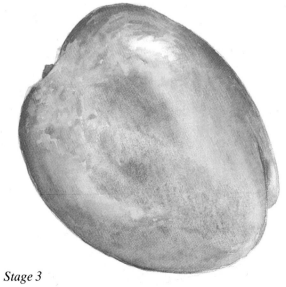

*Stage 3*

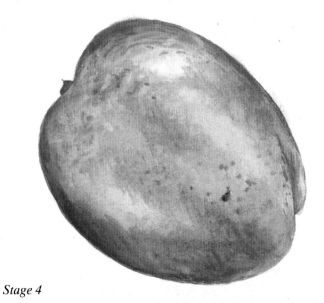

*Stage 4*

20

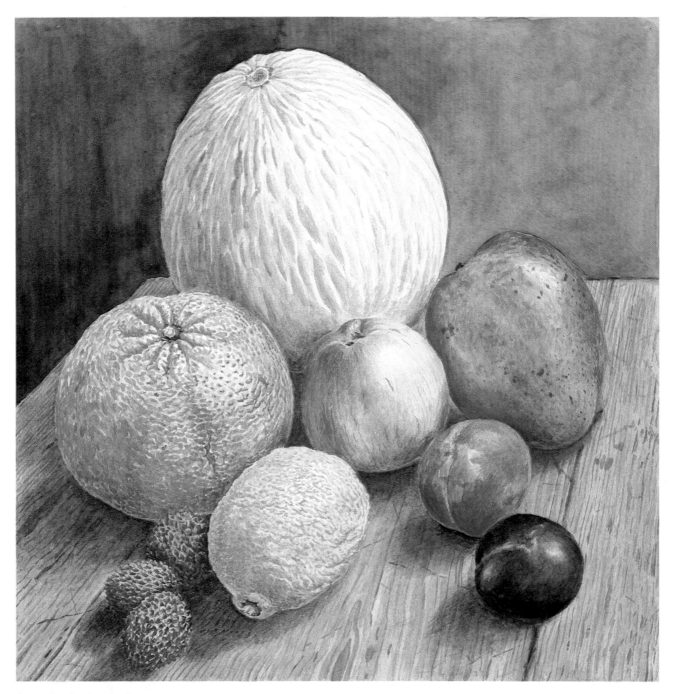

*Stage 5 – the finished painting*

# The garden shelf (page 23)

Original size: 292mm × 292mm (11½in. × 11½in.)
Paper: Fabriano Not 140lb/300gsm
Brushes: Sable no. 4, 7

Still-lifes can be carefully arranged and posed, or they may be chanced upon. You may, for example, come across a group of objects and think 'ah, that would make a good picture!' just as I did with this collection of gardening objects. It had a naturally harmonious composition, with the flower pots nicely balanced by the runner beans that hung over the edge of the shelf, and all I had to do was to remove a few extraneous objects that did not contribute to the overall effect.

The method of execution followed the same lines that we have already studied in the earlier demonstrations and I would only add a few particular points. The earthenware colours were based on varying mixtures of light red and raw sienna, with touches of burnt sienna and Vandyke brown mixed with Windsor violet for the shadows. For the wrinkles on the leather glove and the coiled strands of the string, I used the point of the brush. So long as the brush has a good point a large brush (I used a sable no. 4) is just as good as a small one – I used a larger brush (no. 7) for the foreground and background washes, simply because it is capable of carrying more water. I made sure, though, that the shadows, in particular the cast shadows, were dark enough, by going over them again at the end of the painting process. It is the shadows which make the objects stand out from one another, and give them form and luminosity.

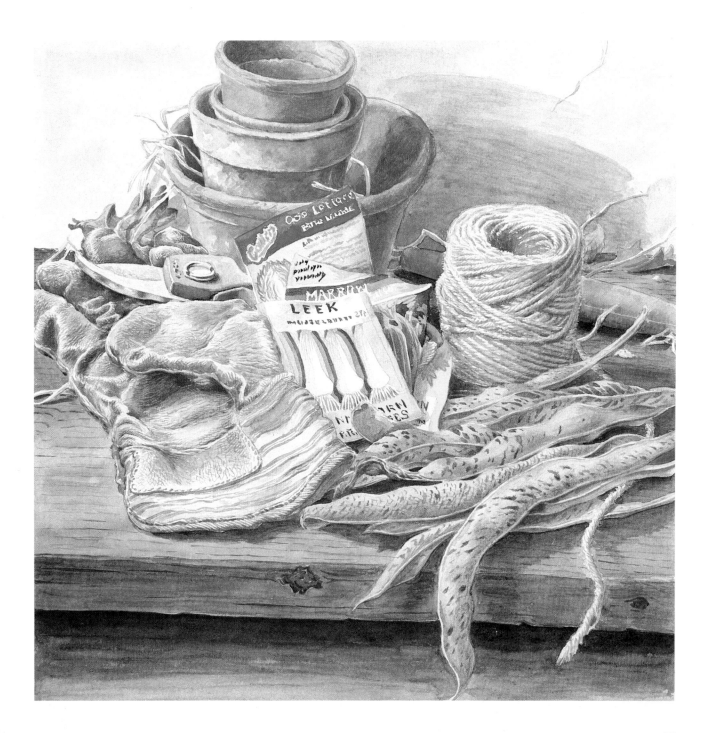

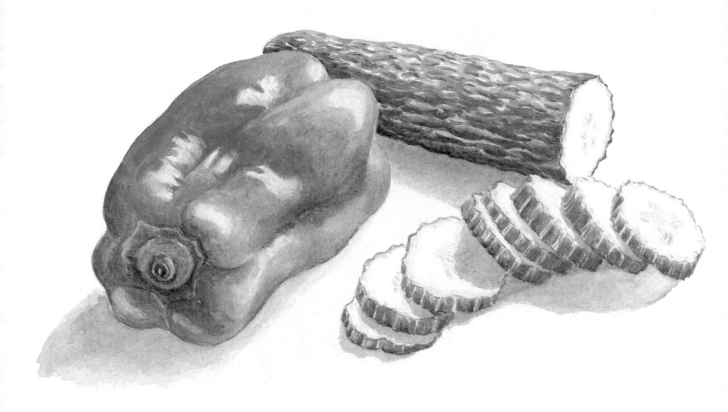

# Vegetables

Original sizes: 225mm × 150mm (9in. × 6in.)
256mm × 187mm (10⅛in. × 7⅜in.)
Paper: (both) Bockingford 140lb/300gsm
Brushes: Sable no. 4, 7; sable no. 4

These paintings or sketches of (right) turnips and a carrot, and of a cucumber and a pepper, were done on the spur of the moment, using vegetables which happened to be on hand, and without my taking any great trouble in their arrangement. (See what vegetables you have in the house and try a quick painting or two.)

Vegetables and fruit provide an infinite variety of texture and colours on their outer surfaces, and by slicing them or cutting them in half you set yourself a further challenge since the cut surfaces are usually to a greater or lesser degree moist.

I did these drawings at a time of year when vegetables were in short supply. In the summer there is a much greater variety from which to choose.

Cabbages (particularly the sort that has curly-edged purplish leaves), globe artichokes and sweetcorn with the husks half open to reveal the golden cobs, make excellent subjects for detailed drawing; while radishes, beetroot and aubergine provide simple shapes and interesting colours.

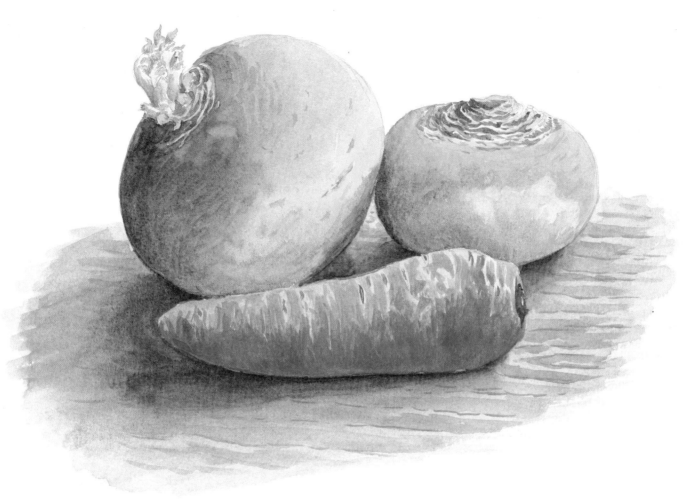

*Turnips and a carrot. It is fascinating, and instructive, to try out a quick drawing or painting of whatever you have available.*

# Onions and garlic

Original size: 187mm × 256mm (7⅜in. × 10⅛in.)
Paper: Fabriano Not 140lb/300gsm
Brushes: Sable no. 4, 5

A special challenge of still-life paintings, because one is depicting objects in close-up, is to represent the texture of various surfaces. Onions, with their layered construction and papery outer covering, provide an excellent opportunity for practising one's skills in this respect. The outermost skin, which was in contact with the soil, may be rather dull, but the inner layers have a silky texture which readily reflects light. I paint them using a fairly dry brush, in several successive glazes, gradually building up the darks and always using brush strokes which follow the vertical contours and the natural graining of the onion. This is accentuated by broader striations at regular intervals. Note that these striations sometimes appear as dark lines against a light background and sometimes as light against dark.

The removal of successive layers of skin reveals subtle colour differences. Indeed onions are full of colour – coppery browns, pinks and ochres, hints of violet and crimson, vivid yellows – the permutations are endless. By way of contrast to these warm hues, I have included the cut onion and two garlic bulbs, one of which reveals pink cloves within.

I have made the table surface and background as unobtrusive as possible, using warm tones which will harmonize with the colours in the onion-skins, but which are dark enough to show the onions and garlic standing out boldly.

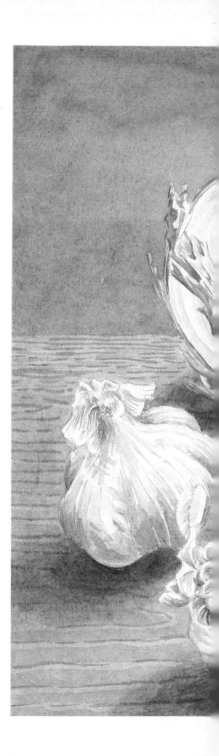

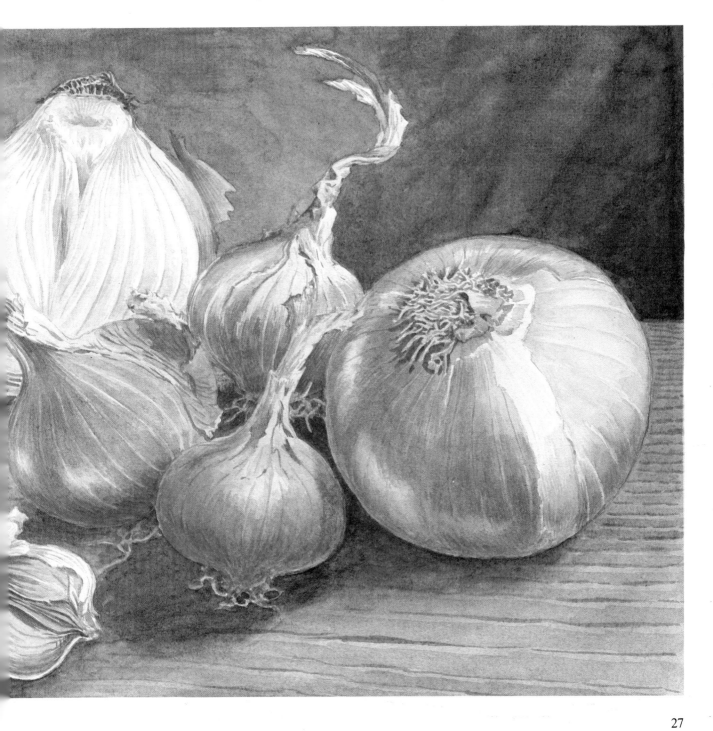

# Two Turkish vases

Size: 280mm × 226mm (11in. × 8⅞in.)
Paper: Fabriano Not 140lb/300gsm
Brushes: Sable no. 5, 2; sable no. 4, 2 (for masking fluid)

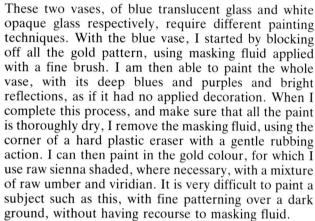

These two vases, of blue translucent glass and white opaque glass respectively, require different painting techniques. With the blue vase, I started by blocking off all the gold pattern, using masking fluid applied with a fine brush. I am then able to paint the whole vase, with its deep blues and purples and bright reflections, as if it had no applied decoration. When I complete this process, and make sure that all the paint is thoroughly dry, I remove the masking fluid, using the corner of a hard plastic eraser with a gentle rubbing action. I can then paint in the gold colour, for which I use raw sienna shaded, where necessary, with a mixture of raw umber and viridian. It is very difficult to paint a subject such as this, with fine patterning over a dark ground, without having recourse to masking fluid.

In the case of the white vase, I first draw in the decorative motif in pencil, and then paint all shadows and reflections, leaving the completely white areas unpainted. In this case masking fluid is unnecessary as the ground colours are all very pale, and the decorations, made up of darker colours, can be painted over them with no significant loss of clarity.

Background and foreground are added after the painting of the vases is completed. For them I use thin washes first and then progressively build up the tones.

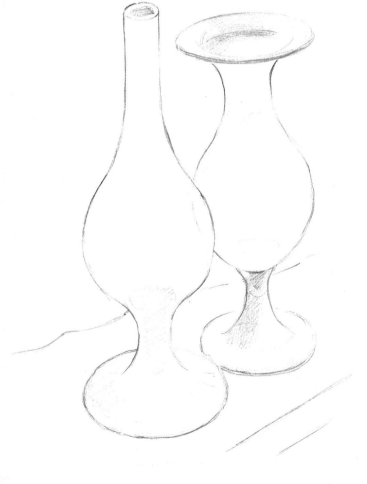

*A preliminary sketch establishing the relationship of the two vases and taking special care over the ellipses.*

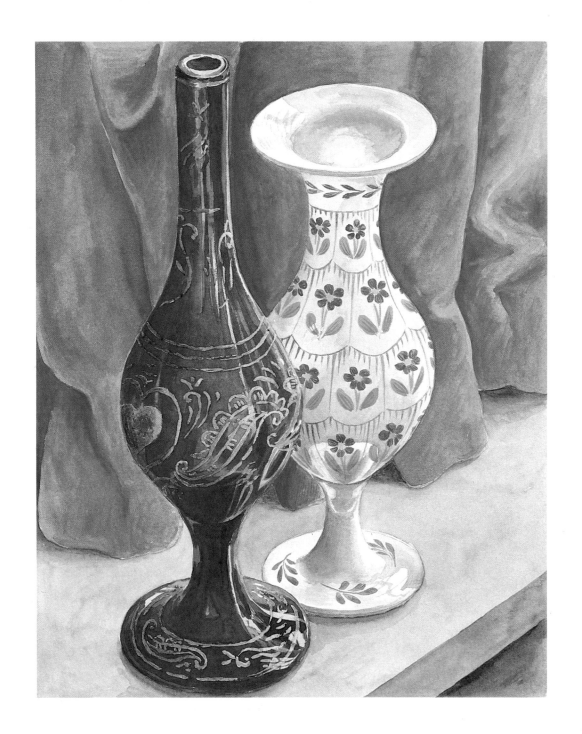

# Two copper pitchers

Original size: approx 285mm × 260mm (11¼in. × 10¼in.)
Paper: Fabriano Not 140lb/300gsm
Brush: Sable no. 4

Glass, being transparent, allows light to pass through it: metal only reflects light. A flat piece of polished metal would act like a looking glass, but most objects in common use are curved or angled, and the distorted images thus produced can add a lot of interest to a painting. Try painting a still life which includes an object made of copper, brass, silver or any other bright metal, or let the metal objects stand on their own, as I have done here. The reflections, which change with every slightest deviation of the angle of view, may seem dauntingly difficult, but do not be put off, it is the overall effect that we are after, rather than perfect accuracy.

The first thing to look for is the colour of the palest (or most brilliant) lights. Since you cannot imbue the pigment with added luminosity (how often one wishes that one could!) the effect of brilliance has to be achieved by the use of contrasts. As you will find no brass colour or copper colour among your paints, so you will have to simulate the appearance of the metals by mixing and contrasting colours.

For the copper surfaces, I start off with a thin mixture of light red and raw sienna with a touch of rose madder; while, for the darker reflections, I use a range of browns, yellows, reds and blues, gradually built up in a series of glazes. The brass base and handles of the larger vessel start with a wash of raw sienna and the 'brassy' effect is achieved by using raw umber and viridian as a basis for the dark areas.

In painting the reflections, after having established my primary wash, I sketch them in lightly to begin with, using a colour only slightly darker in tone. This gives a clear indication of which areas of the primary wash are to be left intact, and I can then concentrate on building up the rich tones and contrasts in the reflections.

In this picture I want the elegant shapes of the two vessels to stand out on their own, without the distraction of other patterns behind them. The white paper alone is a bit stark, so to provide a softer and grainier background, I rub an area around them with blue crayon. Their reflections (they are standing, in fact, on a gloss-white windowsill), when painted over the crayon with Payne's grey, give them stability and prevent them from seeming just to float in space.

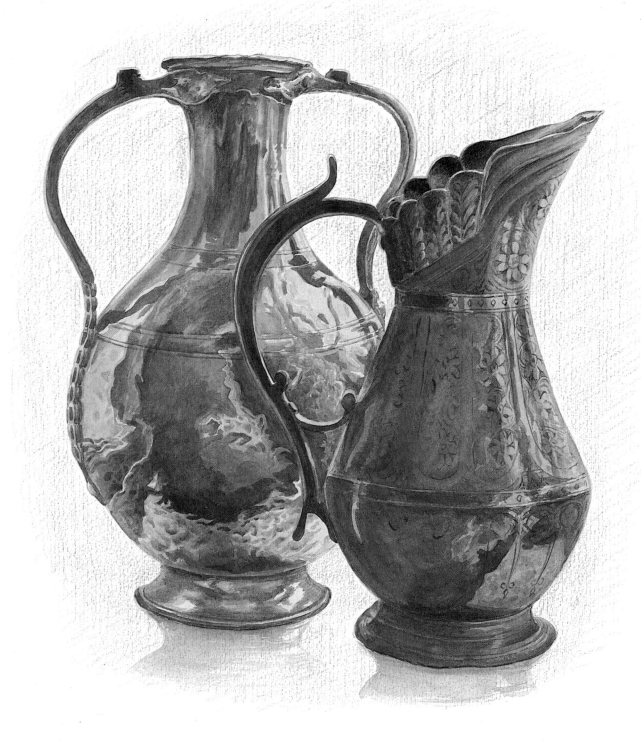

# Conclusion

In any still-life painting, composition is of the utmost importance. If the compostion is ill-balanced or dull, the picture will not be satisfying. I remember once admiring a picture of a red chair. The angular lines of the chair, on which stood a jug, an orange and a lemon, were painted in flat colours against a black background, making a very simple but pleasing composition which contained all the elements necessary to a successful still life.

In the demonstrations in this book, however, I have tended to concentrate on aspects of picture-making which, though not essential to creating a good still life, will, I hope, offer stimulating challenges and prove of general use in the future – the textures of various materials and surfaces, for instance, and the ways in which light is reflected from glass and metal. Whether you employ an impressionistic or a more detailed approach, the objects you paint have to end up recognisable for what they are. I have suggested some techniques for achieving this, and no doubt you will work out others for yourself. In either case you will surely get a lot of pleasure from the process of experimentation, which is half the fun of painting.

*Acknowledgements*

PAINTING STILL LIFE IN WATERCOLOUR

Text, drawings and paintings by Benjamin Perkins

Text, illustrations, arrangement and typography copyright © Search Press Limited 1988

First published in Great Britain 1988 by Search Press Ltd, Wellwood, North Farm Road, Tunbridge Wells, Kent TN2 3DR

*U.S. Artists Materials Trade Distributor*
Winsor & Newton, Inc.
P.O. Box 1519, 555 Winsor Drive, Secaucus, NJ 07094

*Canadian Distributors*
Anthes Universal Limited
341 Heart Lake Road South, Brampton, Ontario L6W 3K8

ISBN 0 85532 615 8

Typeset by Scribe Design, Gillingham, Kent, England
Made and printed in Spain by Salingraf S.A.L., Bilbao